My Name is Grace

A Collection of Stories
about People who Share my Name

By Allison Dearstyne

Dedicated to every girl named Grace; may you always possess the virtue for which you were named!

This book belongs to: _____

The name Grace comes from the Latin word "gratia." The first form of your name in the Middle Ages was "Gracia." The Puritans adopted the name Grace in the 1700's along with other virtue names. The word "grace" has many definitions. It can mean beauty of form, kindness or favor. To the Puritans, it referred to divine grace. This kind of grace is the undeserved love and kindness of God. It is a gift, just like you!

Did you know that there are many great women in history who have shared your name? We will look at these seven heroes named Grace:

Grace Alele-Williams
Grace Bedell
Grace Lee Boggs
Grace Bussell
Grace Darling
Grace Eldering
Grace Hopper

Grace Alele-Williams is an educator who made history as the first Nigerian woman to hold a doctorate degree and the first woman Vice-Chancellor of a Nigerian University. She was born in 1932 in Warri, Nigeria. When she was born, Nigeria was controlled by the British Empire. Little Grace grew up in a patriarchal society, which means that all of the nation's big decisions were made by men. The youngest of five, she looked up to her big brothers and sisters, who each influenced her tremendously. Her father died when she was young, and her mother put little Grace, who was always a math whiz, into good schools.

When she was 18, she was admitted to the University College, Ibadan. She was one of ten women enrolled along with 400 men. After she graduated with a master's degree in mathematics, she became a teacher, inspiring many young women to follow in her footsteps as mathematicians and professionals. As she taught, she began to question Nigeria's education system. Wanting to improve things, she decided to earn her doctorate degree, which would equip her to introduce change. While continuing to teach, she earned her Ph.D. from the University of Chicago in 1962.

The following year, she married Babatunde Williams and together they had five children. They returned to Nigeria, which had achieved independence from Britain in 1960. She was excited about the great changes she would make in the education system. Grace Alele-Williams helped older women become elementary educators with a certification program, rather than a college degree. This allowed many more children to be educated. Seeing a huge need for early childhood education, she introduced a new program in Lagos. Specifically, she focused on educating girls in math and science. Not everyone took well to her ideas. In a patriarchal society, she was highly criticized by some, who felt she was overstepping her role.

But that didn't stop her! She went on to become the Vice Chancellor at the University of Benin and worked hard on behalf of all of the students there. Now an old lady, Grace Alele-Williams has seen many more Nigerian women pursue higher education like she did. When you are sitting in your math class, pay close attention. You could change your world just like trailblazing Grace Alele-Williams!

Grace Bedell was best known as the 11 year old girl who encouraged the presidential nominee Abraham Lincoln to grow his beard! She was born in 1848 in New York, the daughter of a staunch Republican. Little Grace's father kept her informed about politics and his favorite candidates.

1860 was an election year, and Grace's father made it no secret that he wanted Abraham Lincoln to win the election! He showed her a picture of the candidates he supported - Abraham Lincoln and his running mate Hannibal Hamlin. She looked closely at his high forehead, sad eyes, angular jaw and lines around his mouth. As she studied the picture, Grace said to her mother, "He would look better if he wore whiskers, and I mean to write and tell him so."

And that's exactly what she did! This is what she wrote on October 15, 1860:

Dear Sir,

My father has just home from the fair and brought home your picture and Mr. Hamlin's. I am a little girl only 11 years old, but want you should be President of the United States very much, so I hope you won't think me very bold to write to such a great man as you are. Have you any little girls about as large as I am? If so give them my love and tell her to write to me if you cannot answer this letter. I have yet got four brothers and part of them will vote for you anyway, and if you let your whiskers grow I will try and get the rest of them to vote for you. You would look a great deal better for your face is so thin. All the ladies like whiskers and they would tease their husbands to vote for you, and then you would be President. My father is going to vote for you and if I was a man I would vote for you too...
Good bye,
Grace Bedell

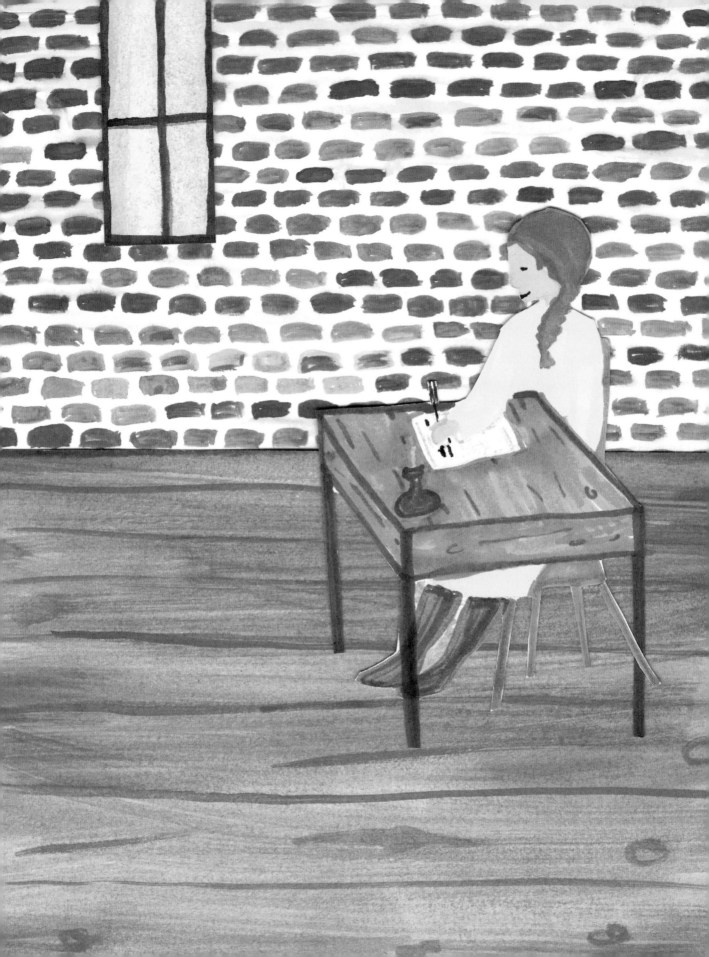

Would you believe it - Abraham Lincoln responded! This is what he wrote back, just four days later:

My dear little Miss

Your very agreeable letter of the 15th is received. I regret the necessity of saying I have no daughters. I have three sons — one seventeen, one nine, and one seven years of age. They, with their mother, constitute my whole family. As to the whiskers, having never worn any, do you not think people would call it a silly affectation if I were to begin it now?

Your very sincere well wisher,

A. Lincoln

Although he made no promises in his letter, he allowed his beard to grow right after their friendly exchange. One month later, Abraham Lincoln had grown a full beard and was elected President of the United States! When he traveled from Illinois to be inaugurated, he stopped right in Grace Bedell's hometown, where thousands gathered to meet the man who would be their President.

Abraham Lincoln gave a speech, and told the sweet story about why he had grown his whiskers. Then he said that if that young lady was somewhere in the crowd, he would like to meet her. Proudly, Grace Bedell's father led her through the crowd and introduced her to the President-elect. He climbed down the platform and sat with her.

"Gracie," he said to her, "look at my whiskers. I have been growing them for you." Then he kissed her cheek!

Abraham Lincoln turned out to be an extraordinary President who led the United States through a very hard time. And who knows if he would have even had a chance to be President if it weren't for little Grace Bedell and her good advice?

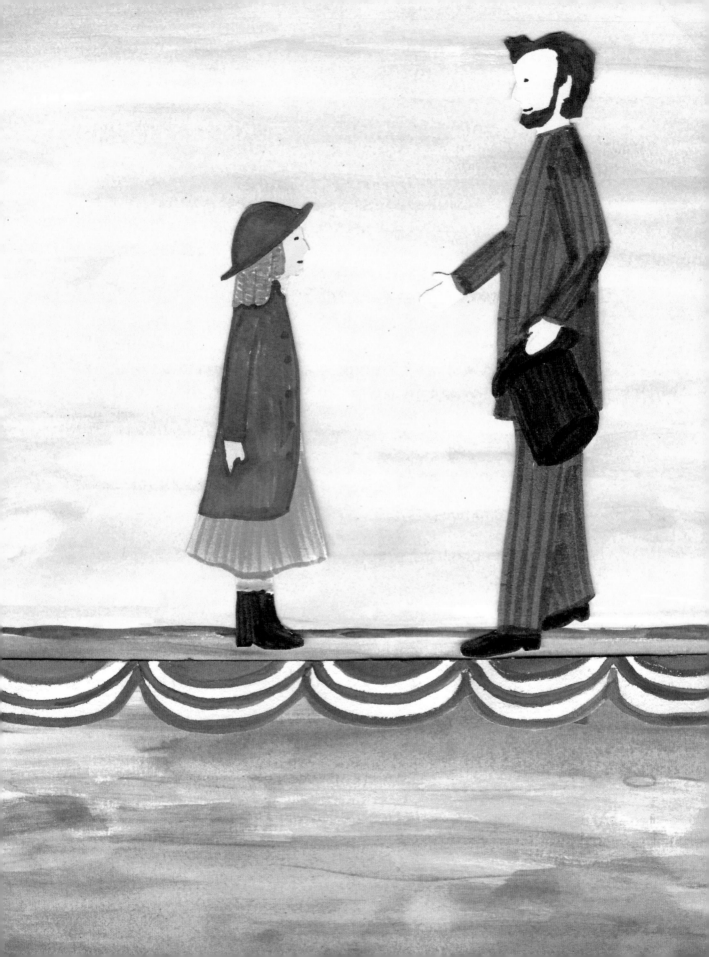

Grace Lee Boggs was a Chinese American social activist, feminist, philosopher and author. In 1915 she was born to immigrants in Rhode Island above the Chinese restaurant that her father owned. Although her mother was illiterate in English, she became a strong feminist role model for young Grace.

She grew up in Queens, and always loved learning. She went to college at 16, and earned a doctorate degree in philosophy from Bryn Mawr College. She especially liked socialist ideas and decided to spend her life changing inequalities in the United States for women and minorities like herself.

Knowing the huge task ahead of her, she said, "activism can be the journey rather than the arrival." She moved to Chicago and began organizing protests against slum housing. In 1953, she moved to Detroit and married James Boggs, a black autoworker, writer and social activist. Together they were a great team and enjoyed a long and happy marriage. As they worked together to fight racism and other forms of injustice in the city, they adopted the methods of Gandhi and Dr. Martin Luther King, Jr. They peacefully protested as the city of Detroit became poorer and more crime-ridden. Grace Lee Boggs became a symbol of hope and resistance there. She created community groups to help the elderly and workers who lost their jobs from the bad economy. She wrote for a weekly newspaper, inspiring people to make good changes in their lives.

In 1992, she co-founded "Detroit Summer," which recruited young volunteers from all over the country to paint murals on walls, repair homes, organize music festivals, and turn abandoned parking lots into community gardens. This organization is still in full-swing! In 2013, she opened the James and Grace Lee Boggs School, a charter elementary school to help underprivileged children. She wrote several books in her life that told her story and her ideas about change.

Grace Lee Boggs always believed that true poverty is the belief that the purpose of life is becoming wealthy and owning nice things. On the flip side, real wealth is in our relationships with other people. Whether or not you grow up with a lot of money, grow up to be rich where it counts, just like Grace Lee Boggs!

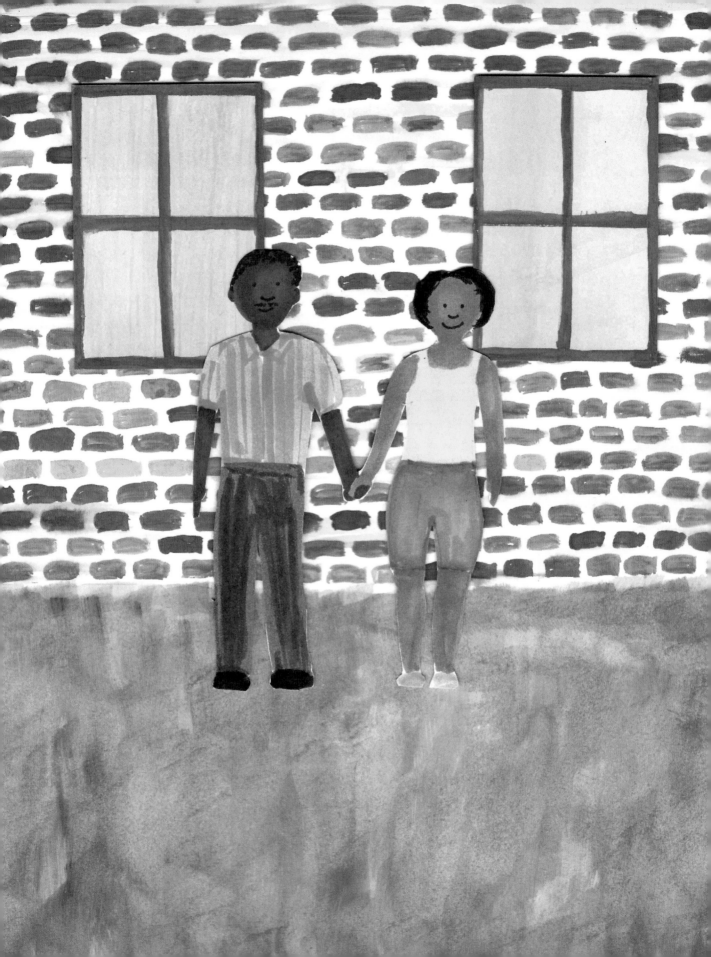

Grace Bussell was an Australian hero who rescued survivors of a shipwreck when she was only 16! In 1860 she was born near Margaret River, which is in Western Australia. As a girl growing up in the Outback, she loved to explore. When she was seven, she discovered a cave! All of her rock-scrambling skills came in handy when a ship wrecked near her home!

The ship *S.S. Georgette* carried 50 passengers between two capes in Australia. On a dark December night, the ship sprung a leak and the pumps failed. The leak put out the fire in the engines of the ship, which set it drifting. The captain had all of the passengers and crew bail out the ship while he sailed toward the shore. He lowered lifeboats into the sea, but they capsized.

All would have been lost if it weren't for the Bussell family's servant, an Aboriginal man named Sam Isaacs. Seeing the disaster from the shore, he ran back to the Bussell's home to call for help to save the passengers. He only found Grace and her mother. Grace didn't waste any time! She and Sam rode on horseback to the steep rocky cliff down to the shore, where the ship was breaking apart in pieces.

To everyone's surprise, she urged her horse down the cliff and into the crashing waves alongside a swamped lifeboat. The passengers, mostly women and children, clung to Grace and her horse as she returned to the shore with them. Sam Isaacs and Grace Bussell spent the next four hours landing all of the ship's passengers as the captain sent down one lifeboat after the next. The lifeboats kept capsizing, and the two brave rescuers did not stop until everyone was saved!

Afterward, the thankful passengers told all about the brave rescue to local newspapers. Grace Bussell was awarded the Royal Humane Society's silver medal, and Sam Isaacs received the bronze. Sadly, his important role in the rescue was downplayed, because of his race. Grace Bussell came to be called "Western Australia's Grace Darling." And who was Grace Darling? Well, you'll just have to keep reading to find out!

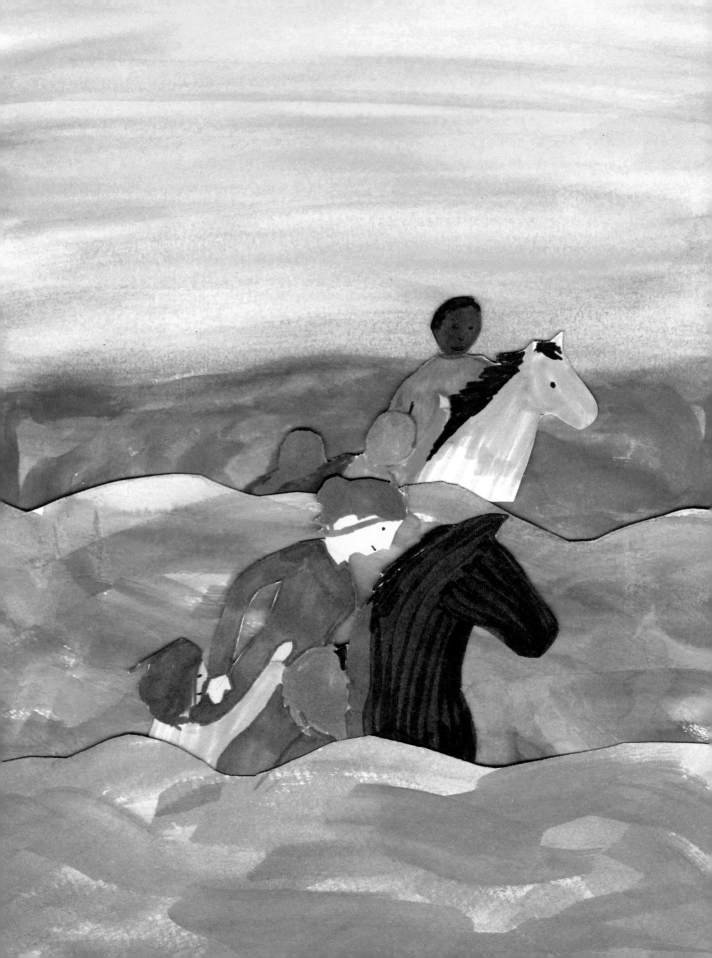

Grace Darling was a young Englishwoman who rescued the survivors of a shipwreck a few decades before Grace Bussell did! She was born in 1815 in Bamburgh, the daughter of a lighthouse keeper named William. She enjoyed growing up in a lighthouse and often helped her father with all of his duties running it.

In September of 1838, she woke up in the wee hours of the morning to see a shipwreck out at sea. A ship called the *Forfarshire* had gotten caught on the big rocks and broken in half. One of the halves immediately sank in the stormy night. It was still storming in the early morning, but spotting survivors on the rocks, she and her father were determined to save them.

Together, they took a rowboat to the wreck. William climbed out while Grace kept the rowboat steady in the storm. Together they rescued five passengers and rowed them back to shore. Then her father and the rescued crew members went out to save the remaining five passengers who stood on the rocks. She was only 22 when she braved the storm to save the survivors.

Their courageous rescue story soon reached the public and Grace Darling quickly became a national hero! Everyone wanted to meet her, paint her portrait, and even propose to her! Grace Darling and her father were both awarded the Silver Medal for bravery by the Royal Institution for their acts of courage.

What a special coincidence it is that two young women who bravely rescued shipwrecked survivors were named Grace! One day you may find yourself needing to summon that kind of courage. If you do, just take a deep breath and think about the "Saving Graces" you read about in this book!

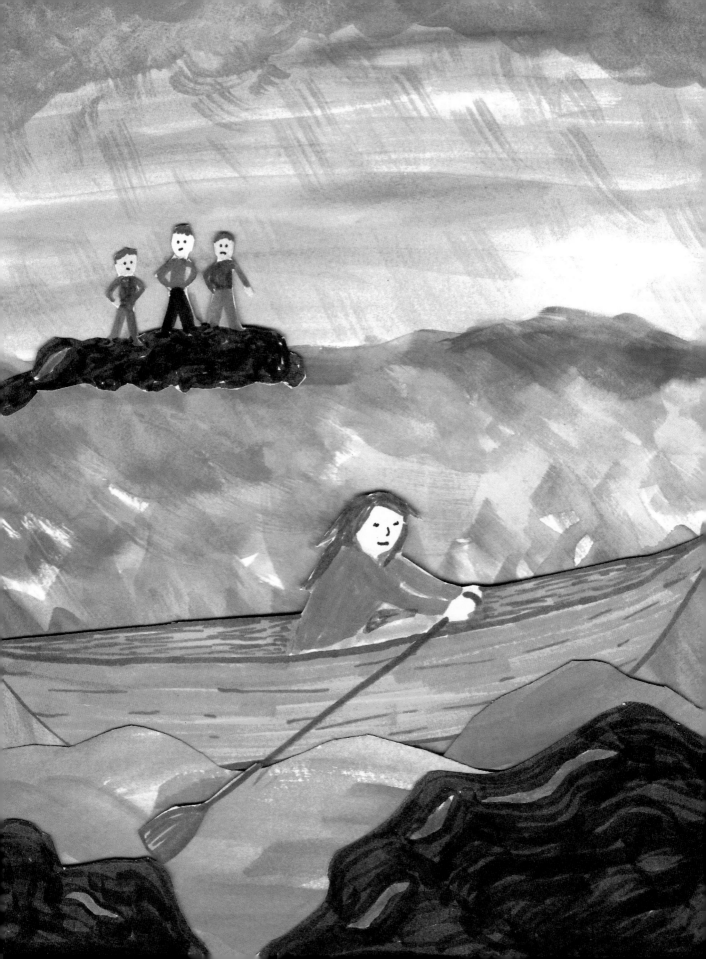

Grace Eldering was an American public health scientist who helped create a vaccine for whooping cough. She was born in Montana in 1900, the daughter of European immigrants. When she was five, she had a terrible bout of whooping cough, which inspired her to find a cure for the dreaded infection.

Whooping cough, also called pertussis or the 100-day cough, is a highly contagious respiratory infection that makes people have coughing fits and breathe in with a "whoop" sound. This infection killed 6,000 American children every year.

After Grace Eldering graduated from college, she moved to Grand Rapids. There, she worked in a laboratory at the Michigan Department of Health and became friends with her co-worker, Pearl Kendrick. In 1932, after an outbreak of whooping cough in the Grand Rapids area, the two women began a side project working on a vaccine to fight it.

After their long work days, they knocked on doors throughout the city to have sick people cough into petri dishes. Then they experimented on the samples. Scientific funding was rarely given for researching infections in those days, and the Great Depression cut the scarce budget for their project even more.

When Pearl Kendrick and Grace Eldering learned that First Lady Eleanor Roosevelt was visiting Grand Rapids, they invited her to tour the lab and explained their project to her. Very impressed with their work, she secured rare federal funding for them. They were given mice, and the women had their first test subjects! In 1934, they ran their vaccine trial on thousands of children, and it proved to be effective.

The women kept working to improve the vaccine. They recruited chemist Loney Gordon, who improved it even more, combining it with a vaccine for diphtheria and tetanus. The vaccine, now called DTaP, is one that you received when you were a baby! No one likes getting shots, but when you have to get your next one, be thankful for people like Grace Eldering, who did her part to keep us healthy!

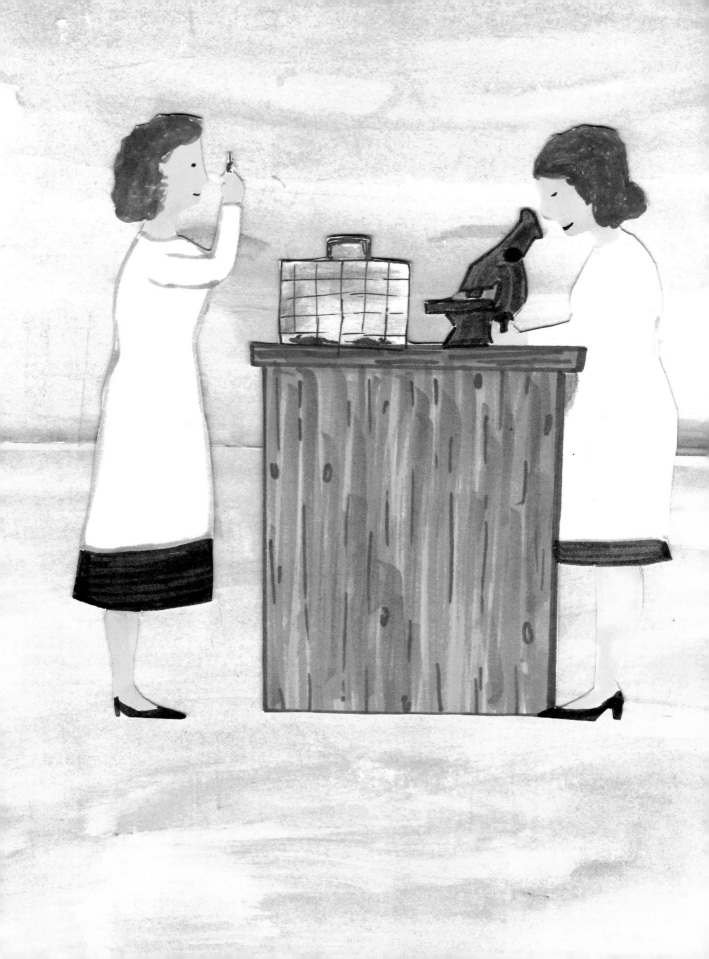

Grace Hopper was an American computer scientist whose work in programming computers is still used today! She was born in 1906 in New York City. As a little girl, she was always very curious. As a seven year-old, she wanted to know how alarm clocks worked. So she found seven alarm clocks and took them all apart before her mother realized what she was doing! Curious kids tend to get into trouble, but curiosity was a trait that served her well throughout her life!

She went to Yale University, where she graduated with a doctorate degree in mathematics. Eventually, she became a professor of mathematics at Vassar College. Life changed for Americans in 1941 when Japan attacked Pearl Harbor, drawing the United States into World War II. Grace Hopper bravely tried to enlist in the Navy to help with the war effort, but she was rejected for being too old and too skinny. Two years later, the Navy made an exception for her, and she was allowed to enlist. She proved to be invaluable to her team, who programmed some of the earliest computers.

After the war was over, Grace Hopper requested to stay in the regular Navy, and they denied her request again because they said she was too old at 38! Instead, she served in the Navy Reserve and worked for a new computer corporation as a civilian. There, she worked with a team to develop the UNIVAC I, the first large-scale electronic computer on the market in 1950.

Grace Hopper made the brilliant suggestion that programming language should use entirely English words to be user-friendly. She thought it made more sense for people to type simple commands in words they understood, rather than typing a bunch of symbols. Everyone said that her idea was out of the question because computers didn't understand English. Still she persisted. She even wrote a paper on the subject, explaining how it could be done, but all of her coworkers kept insisting it was impossible.

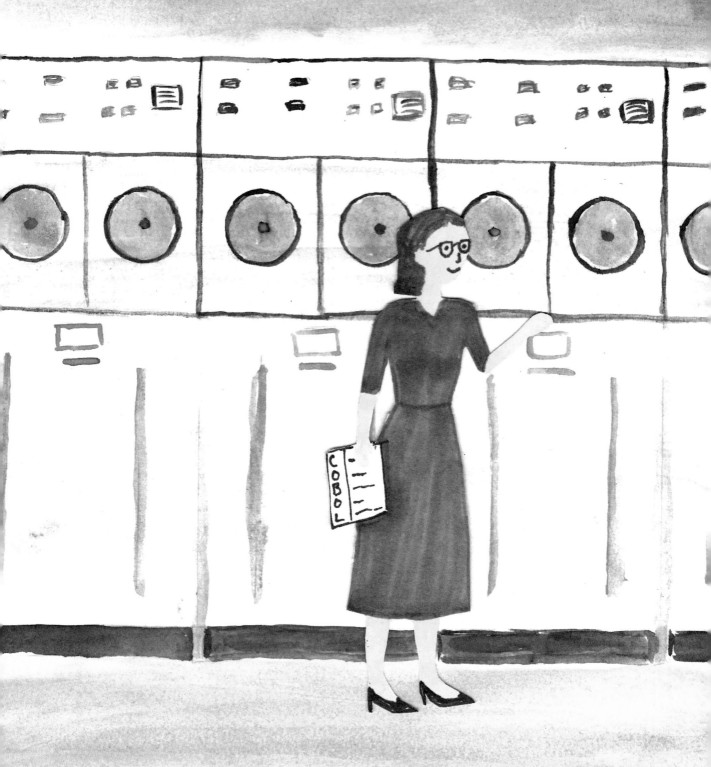

After three years, her idea was finally accepted! Her dream became a reality with the invention of a computer called a compiler. Still, none of the other techies wanted to go near it. They insisted that computers could only do arithmetic, and they didn't believe that she had created one that could do more. But eventually, people began to use it and love it. Her computer language came to be called COBOL, an acronym for COmmon Business Oriented Language. It's a language still used in data processing today. But Grace Hopper's proudest achievement wasn't creating COBOL.

She said, "If you ask me what accomplishment I'm most proud of, the answer would be all the young people I've trained over the years; that's more important than writing the first compiler." She worked as a professor at several universities, well into her old age. Her talent in teaching helped her communicate with a wide variety of people: technical experts, engineers, business leaders, data processors, young students and the general public. A talented writer, Grace Hopper wrote the first computer manual. Her aim was explaining complex things in simple ways. She didn't see the point in doing anything unless you could communicate it clearly.

Grace Hopper cast a vision of what computers would do for society in the future. She always believed that people underestimated what they could really do. This belief was a driving force in her efforts to make computers more user-friendly. People who worked under her leadership nicknamed her "Amazing Grace."

In 1983, Grace Hopper was interviewed by "60 Minutes," and she became somewhat of a celebrity. Her work through World War II and the Cold War became widely recognized. She was promoted in the military and retired in 1991 as a rear admiral at the age of 79. Decades after her death, President Barack Obama posthumously awarded her the highest civilian honor, the Presidential Medal of Freedom, for her contributions to computer science.

Think about all the different ways we use computers today. Grace Hopper envisioned it, long before you were born! Whenever you log in to a computer, think about brilliant Grace Hopper!

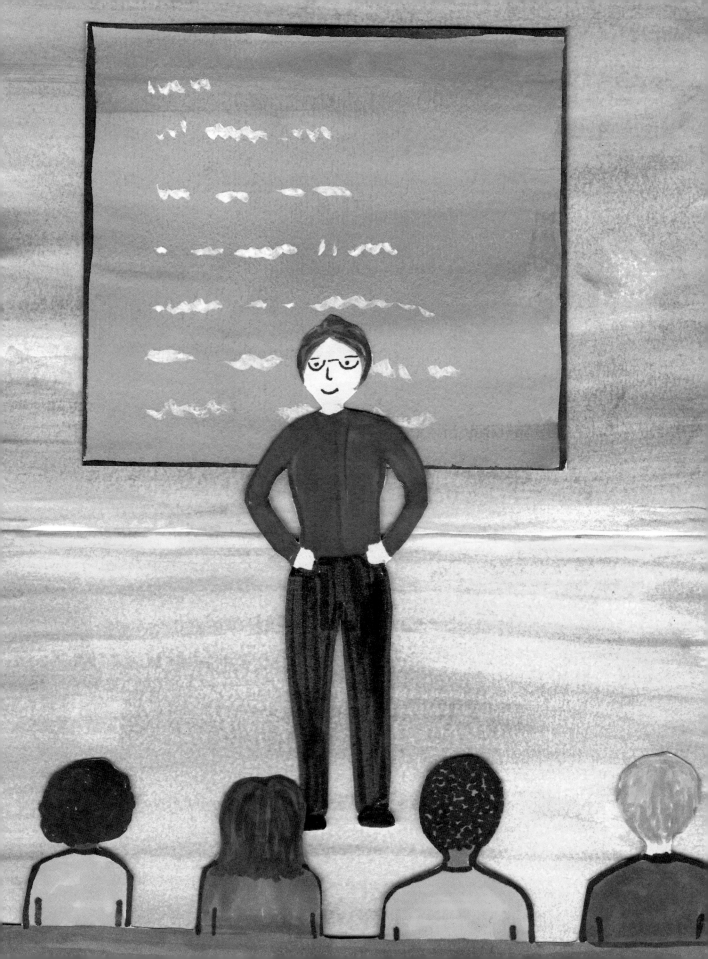

This page is all about you!

_____ was born on

As a baby, Grace _____

As a little girl, Grace _____

Grace is especially good at _____

Grace is often described as _____

Grace makes people laugh when she _____

One day Grace would like to _____

This page is for making a self-portrait. A self-portrait is a picture of you, drawn by you!

Bibliography

"Grace Awani Alele-Williams." *ourlegacyway.com* Legacy Way. Web. 16 May 2020.

"Grace Murray Hopper (1906-1992): A legacy of innovation and service." *news.yale.edu*. Yale News. 10 Feb. 2017. Web. 13 May 2020.

Latson, Jennifer. "The Super Cute Story Behind Abraham Lincoln's Beard." *time.com*. 2020 Time USA, LLC. 15 Oct. 2014. Web. 29 Apr. 2020.

Matthews, Jan and Trevor, Sarah. "Saving Grace: Western Australia's Shipwreck Rescuer, Grace Bussell." *tracesmagazine.com.au*. Traces: Uncovering the Past. 30 Nov. 2013. Web. 30 Apr. 2020.

McFadden, Robert D. "Grace Lee Boggs, Human Activist for 7 Decades, Dies at 100." *nytimes.com*. The New York Times. 5 Oct. 2015. Web. 15 May 2020.

Nameberry.com. 2020 Nameberry, LLC. Web. 29 Apr. 2020.

Shapiro-Shain, "Pearl Kendrick, Grace Eldering, and the Pertussis Vaccine." *ncbi.nlm.nih.gov*. US National Library of Medicine National Institutes of Health. 16 Aug. 2010. Web. 18 May 2020.

Wikipedia contributors. "Grace Bedell." *Wikipedia, The Free Encyclopedia*. Wikipedia, The Free Encyclopedia, 3 Feb. 2020. Web. 29 Apr. 2020

Wikipedia contributors. "Grace Lee Boggs." *Wikipedia, The Free Encyclopedia*. Wikipedia, The Free Encyclopedia, 12 May. 2020. Web. 15 May. 2020.

Wikipedia contributors. "Grace Darling." *Wikipedia, The Free Encyclopedia*. Wikipedia, The Free Encyclopedia, 29 Apr. 2020. Web. 3 May. 2020

Wikipedia contributors. "Grace Hopper." *Wikipedia, The Free Encyclopedia*. Wikipedia, The Free Encyclopedia, 2 May. 2020. Web. 14 May. 2020.

Wikipedia contributors. "SS Georgette." *Wikipedia, The Free Encyclopedia*. Wikipedia, The Free Encyclopedia, 27 Feb. 2020. Web. 3 May. 2020

Zarrelli, Natalie. "Whooping Cough Killed 6,000 Kids a Year Before These Ex-Teachers Created a Vaccine." *history.com*. History. 16 Apr. 2019. Web. 18 May 2020.

Made in the USA
Coppell, TX
13 February 2021